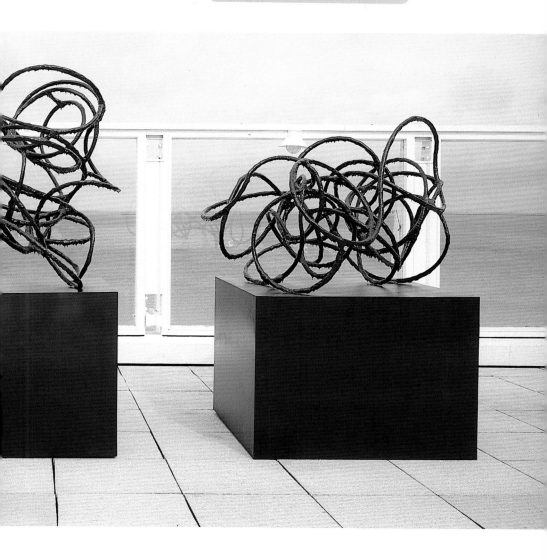

3

Nick Evans: Material Cultures

Sara Hughes, Curator
Susan Daniel, Director

Nick Evans is the fourth artist and the first sculptor to participate in the Tate St Ives Artist Residency programme at number 5, Porthmeor Studios, St Ives. One of the next generation of artists to come out of Glasgow School of Art, his latest work engages with current discussion on the formal potential of the art object and its continued function as a mechanism of critical debate.

Employing a range of media from fibreglass resin, steel, poured and painted aluminium and ceramic, his intuitively constructed, quasi-figurative forms have immediate visceral impact. But the vitality of Evans' gestural figures is as much achieved through a joy of making as through a radical sampling and remixing of twentieth-century Western aesthetic strategies.

For Evans, this ongoing evaluation in his work seeks to renegotiate a direct relationship between material and meaning. Artists who have motivated such critical discourse towards object-making include Terry Atkinson and Asger Jorn, which in part explains Evans' perverse combination of art political rigour and irreverence, combined with expressive 'direct fabrication' (rather than carving). This pertinently recalls (and immediately sabotages) the ethos of 'truth to materials' demonstrated by Barbara Hepworth and associates from the 1920s.

Evans often interplays these and other formal relationships within a (conceptual) matrix born from cultural systems and ideologies, such as the Deleuze-Guattari Rhizome Theory Clarrie Wallis describes. This offers a testing ground in which to graft, overlap, manipulate, counterpoint and subvert extrapolated art historic samples or 'specimens': cubism, constructivism, art informel, abstract expressionism, pop and graffiti art, to name but a few.

The resulting dialogues or 'interrogative encounters' between the material/form, conceptual/functional, historic/contemporary elements of Evans' work(s) are deliberately unresolved, prompting multiple interpretations. As the artist intends, each viewer will configure the experience of the work on their own terms, with their own cognitive baggage. Whilst, for example, this could be a general comment in itself about exclusive (self-referential) vocabularies prevalent in modernist abstraction, Evans shares the possibility of plural narratives evolving from contemporary sculpture, where a complex of forms and meanings can coexist for the post-modern consumer.

In her insightful essay, Clarrie Wallis, Curator at Tate Britain traces the developments leading to Evans' new works, putting them in context with contemporary practice and critical debate. We are grateful for her valuable contribution to the Artists' Residency Programme. Many thanks also to Glasgow-based artist Gregor Wright, for his tangential response to Evans' process and vocabularies.

We would like to acknowledge funding from the Hope Scott Trust; the Scottish Arts Council; Arts Council England, South West; Tate St Ives Members and Tate Members. Thanks particularly to Norman Pollard for supporting the practical aspects of the residency programme. University College Falmouth provided technical support and we are grateful to Jeff Hellyer, Joe Waller, Andy Currie and Will Schuman. Thanks also to Jo and Jason Wason and the Gaol Yard Studios for lending kilns. Mary Mary, Glasgow and Sarah den Dikken have also given editorial support in the production of this catalogue. Finally, our warmest thanks to Nick who's enthusiasm and commitment has inspired us all.

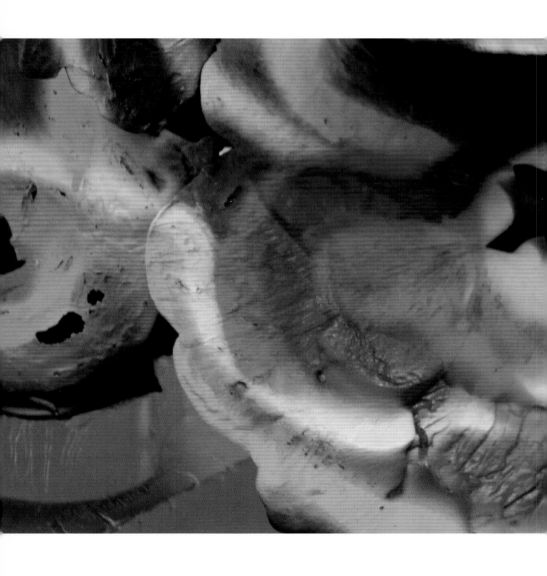

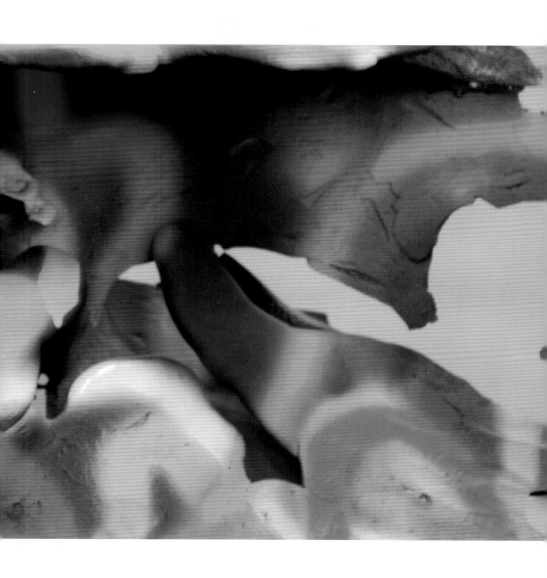

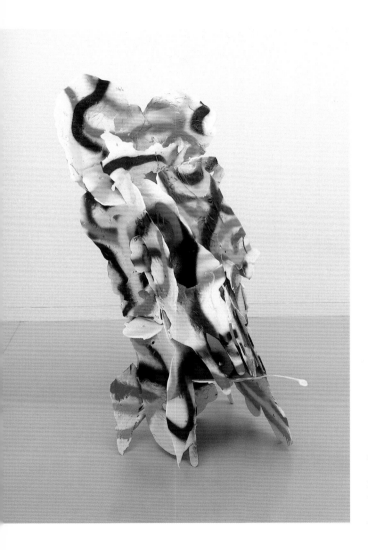

White Creature Forms
2006
Spray paint on aluminium
85 x 50 x 50 cm
Photo: Dave Clarke and
Andrew Dunkley © Tate

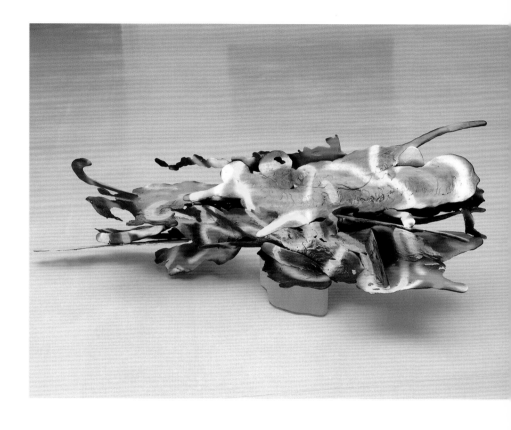

Above
Black Creature Forms
2006
Spray paint on aluminium
180 x 40 x 50 cm
Photo: Dave Clarke and
Andrew Dunkley © Tate

Page 2–3
**Memorials to the Closed
System Schematic**
2006
Steel, plaster, fibreglass,
coloured resin on painted
plywood and metal base
1. 110 x 110 x 220 cm
2. 120 x 120 x 220 cm
3. 255 x 110 x 220 cm
Photo: Dave Clarke and
Andrew Dunkley © Tate

Page 6–7
Black Creature Forms (detail)

Abstract Machines
Clarrie Wallis

Nick Evans' sculptures have a ghost-like quality that haunts and disrupts their modernist forms. Revelling in an excess of historical and cultural referents, there are, in Evans, two competing artists; a latter-day modernist and a knowing postmodernist. The first often appears to take his cue from Modernism's liberating mission, a belief in spontaneity and the creative spirit, while the second has no faith in notions of authenticity and unmediated expression. His roughly modelled polychromatic sculptures lay claim to a kind of expressiveness that rejects traditional conventions of composition to plumb the depths of the unconscious. Yet Evans is without a doubt a sampler as much as a maker. The unabashed postmodernist in Evans adopts imagery, concepts and ways of making art to his own interests. Thus the sculptures occupy a field in which contrasting aspirations coexist. Evans' curiosity lies in revisiting and recasting languages, taking historical forms, mixing them with other influences in order to come up with a synthesis that indicates, or points towards, a new reality or set of conditions.[1]

One constant theme that underpins Evans' career has been the desire to question the capacity of art to serve as a centre for political discourse and cultural enquiry. This interest has, in part, been shaped by his experience of studying on the Environmental Art Course at Glasgow School of Art. The course, set up in the mid 1980s, promotes the interdisciplinary nature of art practice – employing methods and raising issues traditionally associated with politics, sociology, ethnography or anthropology in an attempt to renegotiate the limits of art. This discursive approach continues to influence his practice. Evans is interested in questioning the limits of visual art as a structure through which to engage with social debate. To this end the artist seeks out narratives from a wide variety of sources. Through a process of simplification and deconstruction, he filters a framework of literary depictions and political and social ideologies into works that encompass the humanistic and personal elements of such circumstances and idealisms. Works become totem-like, standing in for a larger action or experience – monuments to a universal ideal.[2]

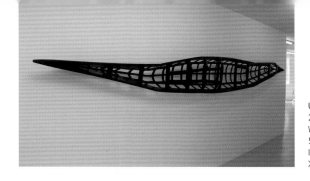

Untitled (Kayak)
2003
Wood, string, bitumen paint
50 x 500 x 50 cm
Installation view, Britannia Works,
Xippas Gallery, Athens 2004

In his early sculptures Evans explored the link between the aesthetics of Modernism and the politics of colonialism, which he describes as 'a form of conceptual art, whereby the materials and the forms used serve to make visible a theoretical position or thematic concern.'[3] This can be seen in *Untitled (Kayak)* 2004, a life-size replica of a West Greenland kayak built from a set of plans drawn up by a Danish ethnographer, who lived with the Inuit community and initiated a renaissance in boat building. Using traditional materials and techniques – including taking all the measurements for the boat from his own body – Evans' kayak is a faithful rendition. The work explores the decline of skills within the Inuit community, which is an outcome of the pressures linked to the modernising influences of Denmark's colonial power. While the process of construction evoked issues traditionally associated with sculptural practice, for example, ideas around mass and volume, the relationship between the interior and exterior of the object, the formal logic of the pure form was subverted through the cutting and rejoining of the kayak's frame in five sections to form a twisted whole. As the artist explains, 'I have taken this inverted colonial logic and adopted its text as a kind of sculptural formalism.'[4] These links are further developed in works such as *Portrait of Amilcar Cabral (Could it be a Bantustan?)*, 2002 a semi-abstract relief of the face of the Leader of the National Liberation Movement of Guinea who was assassinated in 1973, on the eve of National Independence and *Lumumba is Dead (Long Live Lumumba)* 2002, an installation in response to the martyrdom of the African leader Patrice Lumumba (1925–61). The history of the African continent is, as Evans highlights, a story constantly overwritten by the (self-) destructive forces of Modernity: industrialisation, colonisation and social unrest.

If Evans' practice reflects new perspectives on the debates surrounding Modernism, he is interested in understanding rather than parodying these issues. In this way we can see his practice as signifying both a re-engagement with its more radical aspects and, in part, a critique of its failings. Evans is intrigued by social alternatives that didn't come

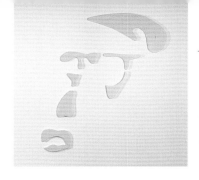

Portrait of Amilcar Cabral
(could it be a Bantustan?) (detail)
2002
Marble
200 x 200 x 3 cm
Photo: Alan Dimmick

into existence – something the cultural theorist Kodwo Eshun has described as 'past, potential futures' – which allows for different perspectives on the present.[5] By the same token, critical theory has successfully undermined a belief in Modernist universalism, and debates around post-colonialism have made us aware of the variety of different versions of modernity created by different political realities around the globe. It has become clear that there isn't one Modernity but many, each of them representing a particular place and experience. Thus, for Evans, such a concern is more than a return to previously accepted forms of Modernity, rather it implies a revisionist definition of modernity and the ways in which art today might attempt to deal with history.

In a recent essay[6] the critic Jan Verwoert proposes that a major strand of contemporary practice is devoted to the re-casting of cultural material; artists today are finding new ways of incorporating references within their practice. He argues that the parameters that define the concept and practice of appropriation as it was proposed in the 1980s have changed. This is a consequence of, or rather an element in, an ongoing and significant transformation of the categories in which history is understood. Verwoert goes on to describe how the original concept of appropriation was intrinsically linked to a post-modern discourse that presupposed the end of modernity and suggested that history could only be encountered in the commodified form of dead artefacts. However, with the experience of global upheavals in the 1990s, it became evident that history refused to remain shelved. Verwoert suggests that history today is experienced as an open continuum and that the ghosts of the past are still among us. Art that references ongoing historical processes therefore tends to operate within the framework of 'invoking the ghosts of unclosed histories in a way that allows them to appear as ghosts and reveal the nature of their ambiguous practice.'[7] In this light Evans invokes diverse spirits such as such as George Grosz (1893–1959), Henry Moore (1898–1986) and Asger Jorn (1914–73), not as art historical 'tropes' or nostalgic references but rather as a form of appropriation that retains the historical depth of the distinction between

original and copy. This opens up a new form of historical consciousness; sensitive to its own construction that is the result from a negotiation between past and present forms.

For example *Pieces of the Dialectical Terror Machine* 2005 – its title poking fun at the language of art criticism – consists of two monumental, brutalist forms, poised on open rusty metal plinths. Fashioned from polystyrene casually coated with plaster and coloured resin, these craggy forms retain figurative associations, of a toppling figure within the shadows of a giant bludgeoning device. It is reminiscent of Aristide Maillol's (1861–1944) sculpture *The River* 1938–43, of a woman who seems to be falling off her plinth, or on in its visceral physicality, Franz West's (b 1947) lumpen forms such as *Sisyphus VI* 2002. If the sculpture seems to speak a slurred jumble of twentieth century sculptural languages, the dialectic indicated in the title is an opened one, referring to ways of thinking about art as a producer of effects and processes, not necessarily meanings.[8] Sculptural languages are mixed to create a stew of different formal and conceptual positions, with the artist revelling in their impurity. Here Evans draws from the philosopher Gilles Deleuze (1925–95) and the psychoanalyst Felix Guattari's (1930–92) concept of the rhizome, which rejects hierarchical (arboresecent) organisation in favour of a 'rhizomatic' growth. This term therefore describes a methodology that allows for multiple nodes that point towards a mapping rather than a tracing. What distinguishes the map from a tracing is its openness, presenting multiple options, as opposed to the tracing, which being directive always comes back 'to the same'. According to Deleuze 'the map fosters connections between fields and is open and connectable in all its dimensions; it is detachable, reversible, susceptible to constant modification. It can be torn, reversed, adapted to any kind of mounting, reworked by an individual, group or social formation. It can be drawn on a wall, conceived of as a work of art, constructed as a political action or as a meditation.'[9] In this light, *Pieces of the Dialectical Terror Machine* 2005 is suggestive of some sort of mechanism. The quasi-figurative forms

Pieces of the Dialectical Terror Machine
2002
Coloured polyester resin over plaster
and polystyrene on metal stand
1. 210 x 120 x 120 cm
2. 270 x 50 x 37 cm
Photo: Alan Dimmick

and gestural surfaces knowingly combine visual stereotypes into contradictory, non-hierarchical elements, open to interpretation.

Evans' interest in Asger Jorn – co-founder of both CoBrA and the Situationist International – lies in his allegiance to a kind of borderline abstraction based in a materialist conception of practice. Striving for spontaneity and experimentation Jorn's career encompassed primitivist figuration, explorations in ceramics and collaborations with various political-aesthetic groups. As Edward Lucie-Smith wrote in *Studio International*, October 1966, Jorn 'bases himself on the medium: he tries to collaborate with the actual materials he is using, in order to give substance to visions which are as much the property of the paint on the canvases as of his own imagination.'[10] *Figure X* and *Figure Y* 2006 mark a transition for Evans that can be characterised as a move away from explicitly social themes towards an exploration of materials and the more radical aspects of formalism.[11] As Evans explains 'I want to make a kind of abstract art which like Asger Jorn's doesn't affirm abstractions grandiose claims. I think it is possible to exercise formal rigour as a critical weapon.'[12] The works are the result of a process of randomly cutting and reforming basic elements to create new entities. While clearly based on organic forms, abstract and figurative elements are held in balance. For example, *Figure X* 2006 was made from a modular form, cut up and reconfigured into a work that recalls the cubist sculptor Alexandro Archipenko's (1887–1964) geometrically stylised forms. Likewise the small ceramic pieces such as *Models X, Y, Z* 2005 or *Models B-J* 2006 are intuitively made by finger pinching and breaking clay into forms that, in their raw vitality have something in common with Auguste Rodin's (1840–1917) fragments of body parts. They are glazed in even more vibrant colours – undiluted primaries, with black, whites and greens.

White Creature Forms 2006 and its companion piece *Black Creature Forms* 2006 are again concerned with the process of making 'as an event which coalesces out a process of seemingly random acts or occurrences.'[13] They are constructed from basic

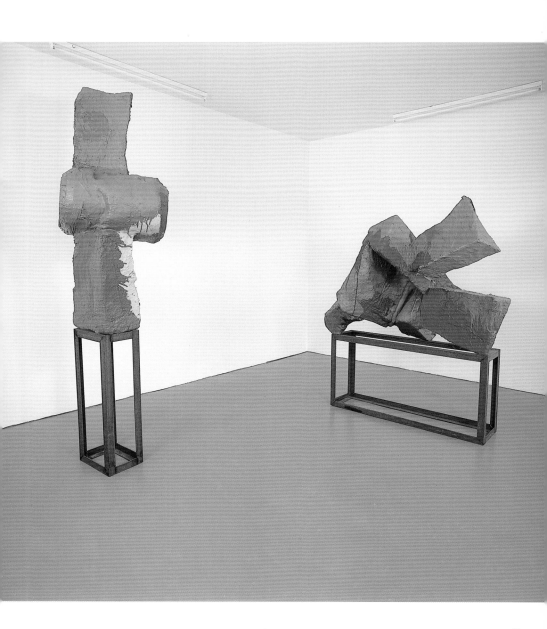

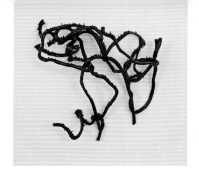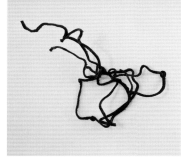

elements whose form is the result of the aluminium encountering 'conditions of flux' – in this case being melted and then poured onto the floor. These shapes were fitted together until Evans felt that there was a sense of formal resolution. In this way structure and form are a direct consequences of the process of making and assembly and the basic properties of the material. However, Evans spraying the sculpture with neo-expressionist graffiti or some sort of psychedelic camouflage, undermined the finished form, in turn disrupting any coherent reading of the surface. A series of three other works collectively titled *Memorials to the Closed System Schematic* 2006 extend ideas behind the *Untitled* wall works of 2005 into epic abstract gestures of rhythms, or mannerist parodies of abstract expressionist mark-making. Conceived for the roof terrace at Tate St Ives the viewer is able to consider the surrounding landscape by literally looking through these open waveforms. In so doing, Evans hints at the history of St Ives as 'a metropolitan colony entrenched in an often ahistorical relationship with landscape, authenticity and primitivism.'[14]

All Evans sculptures carry an awareness of the problematic relationship between form and meaning. In juxtaposing a generic (modernist) sculptural language with attempts to subvert the aesthetics of formalism, the artist seems to be offering an examination of the process of interpretation and the limits of visual art as a means through which to engage with social debate.[15] This is enriched, as Laurence Figgis has described, 'by the artist's critical absorption in problems of the "other" and the self authenticating ruses of art, resulting in an unsentimental primitivist aesthetic.'[16] *Figure X* 2006 encapsulates the contest that is at the heart of Evans' work. As he explains,'the formalism I am interested in is one in which the working practice, the material facts, the inconsistencies, accidents and coincidences that occur in studio practice keep the work alive... Ultimately the works' formal qualities are used as a quasi-linguistic device rather than an end in its own right.'[17] While cautious of the potential for art to engage in critical discourse, it is also, you sense, the ideal that drives his work on.

Opposite page
Untitled (2 parts)
2005
Coloured polyester resin over rope
1. 62 x 51 x 36 cm
2. 65 x 51 x 76 cm
© Sorcha Dallas and the artist
Photo: Alan Dimmick

Below
Figure X
2006
Coloured polyester resin and
fibreglass on metal stand
220 x 200 x 150 cm
Photo: Dave Clark and
Andrew Dunkley © Tate

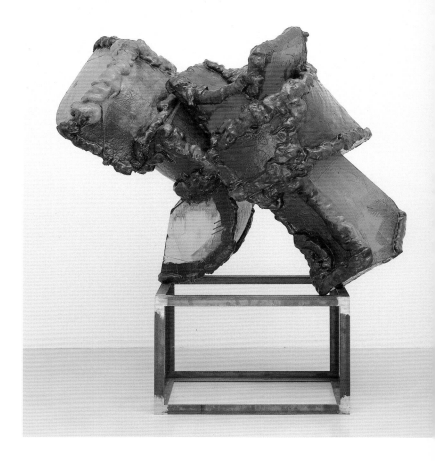

Figure Y
2006
Coloured polyester resin and
fibreglass on metal stand
250 x 220 x 150 cm
Photo: Dave Clarke and
Andrew Dunkley © Tate

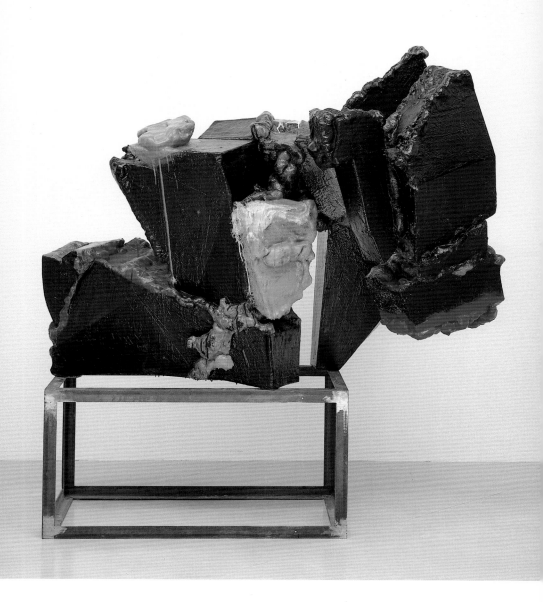

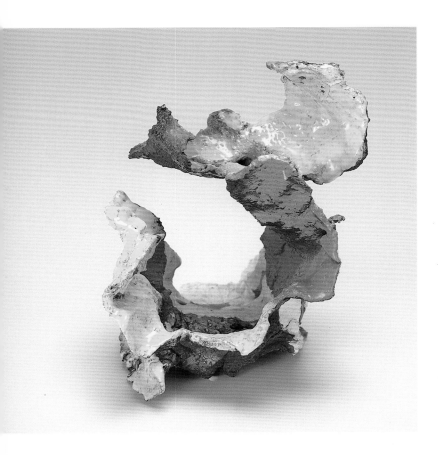

Model D
2006
Glazed, painted terracotta
h 25 cm
Photo: Simon Cook

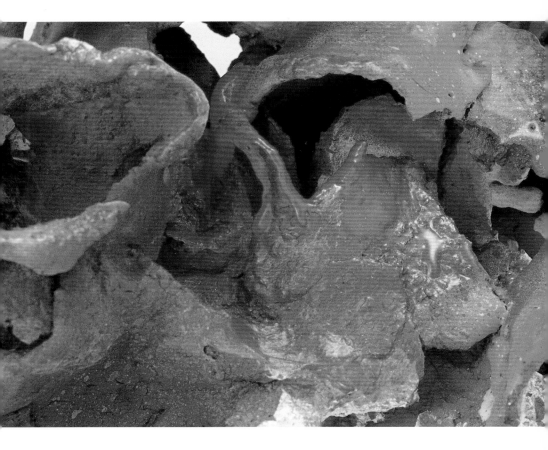

Model B (detail)
2006
Glazed, painted terracotta
h 30 cm
Photo: Simon Cook

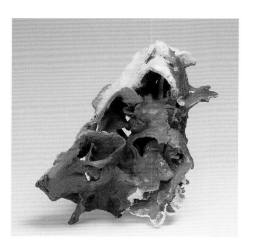
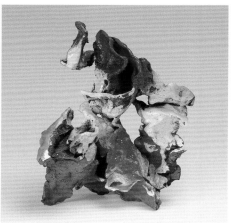

Models B-J
2006
Glazed, painted terracotta
Dimensions variable
Photo: Simon Cook

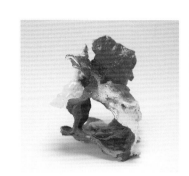

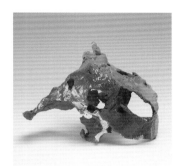

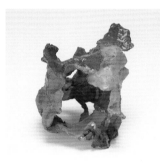

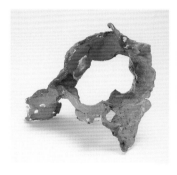

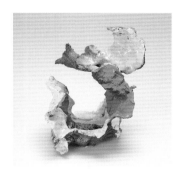

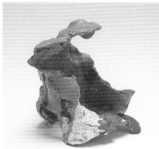

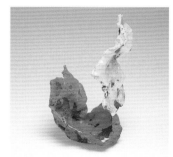

Gregor Wright
Neither Here Nor There
2006
Courtesy of the artist

> inventory

> You are carrying: a book.

> examine book

> It is the catalogue for an art exhibition. It contains various full colour pictures of the artist's work as well as an essay titled 'Neither Here Nor There'.

> read book

> The essay seems to take the form of an old interactive fiction computer game. It starts with the inventory command for a nameless character (presumably yourself) who appears to be carrying nothing but a book. The typically concise description tells you that the book is an artist's catalogue that contains pictures of recent work as well an essay with the same title as this one. There then follows a brief description of the essay. This sentence appears. Then it continues:

Neither Here Nor There

Algol (Beta Persei) is a bright star in the constellation Perseus where it represents the eye of the Gorgon Medusa. The name comes from the Arabic al-ghul, 'the ghoul', and means 'demon star'. Astrologically, it is considered the most unfortunate star in the sky.

Betelgeuse (Alpha Orionis) is the second brightest star in the constellation Orion. The name is a corruption of the Arabic yad al-jawz, or 'hand of the jaw'. A series of transliteration errors have led to the modern rendering of Betelgeuse, which is pronounced BET-el-jooz.

Phobos is the larger and innermost of Mars' two moons. It is named after Phobos, the son of Ares (Mars) in Greek Mythology. It is one of the smallest known moons in the solar system and orbits closer to a major planet than any other. The peculiarities of its orbit mean that it will eventually be destroyed.

The essay comes to an abrupt end without describing anything further.

> quit

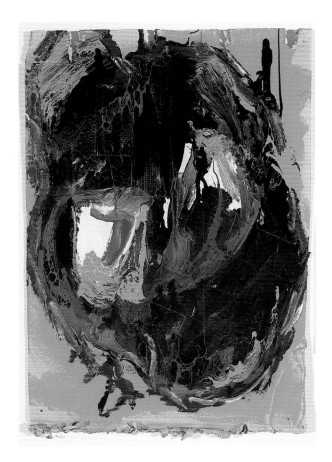

Black Face
2006
Oil, charcoal, gloss and
emulsion paint on cardboard
40 x 30 cm
Photo: Simon Cook

Opposite page
Head
2006
Oil, charcoal, gloss and
emulsion paint on cardboard
60 x 40 cm
Photo: Simon Cook

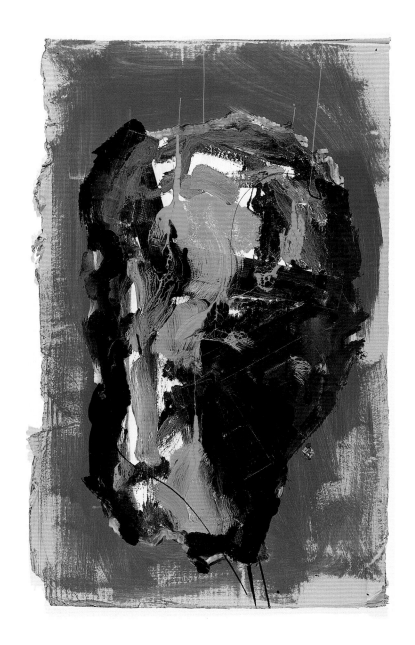

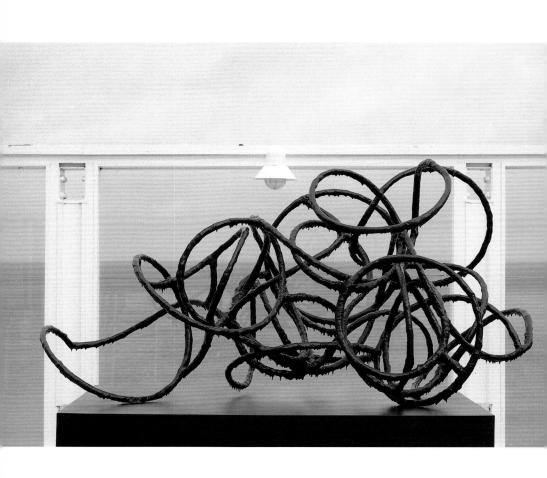

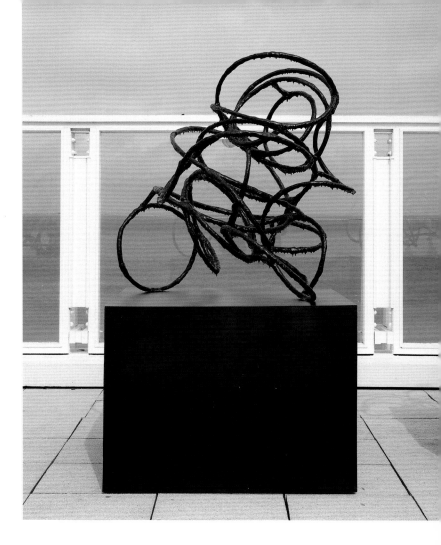

Memorials to the Closed System Schematic
2006
Steel, plaster, fibreglass, coloured resin on
painted plywood and metal base
1. 110 x 110 x 220 cm
2. 120 x 120 x 220 cm
3. 255 x 110 x 220 cm
Photo: Dave Clarke and Andrew Dunkley © Tate

Notes

1 Email exchange between artist and author, 13 June 2006

2 See press release for artist's talk, Mary Mary, Glasgow, September 2005

3 Artist's statement, Autumn 2005

4 Artist in correspondence with author, 10 May 2006

5 This is a concept that Kodwo Eshun has developed from Giogio Agamben's reading of potentiality

6 *Apropos Appropriation: Why Stealing Images Today Feels Different*, Tate Triennial: New British Art 2006, Tate Publishing, 2006, pp.15–21

7 Ibid, p.21

8 Email exchange between artist and author, 4 August 2006

9 See Deleuze, Gilles and Felix Guattari. *'Rhizome' in A Thousand Plateaus: Capitalism and Schizophrenia*, University of Minnesota Press, 1987 p.13. Translation by Brian Massumi.

10 Edward Lucie-Smith, 'A Rich Diversity: London Commentary' , *Studio International*, October 1966, p.199

11 Asger Jorn, 'Forms Conceived as Language', *Cobra No 2*, 1949, trans. Sarah Wilson, *Aftermath: France 1945–54*, exh. cat., Barbican Art Gallery, p.107

12 Artist in conversation with author, 11 June 2006

13 Email exchange between artist and author, 4 August 2006

14 Email exchange between artist and author, 4 August 2006

15 See Nick Evans 'Soup du Jour? Some Problems with New Formalism', *Variant*, Issue 16, pp.35–37

16 Laurence Figgis, Nick Evans Biography, Sorcha Dallas web site, www.sorchadallas.com

17 Artist in conversation with author, 11 June 2006

Biography

Born in 1976, Mufulira, Zambia
Lives and works in Glasgow

2000
BA (Hons) Fine Art, Sculpture and Environmental Art, Glasgow School of Art

1999
Royal College of Fine Arts, Stockholm

1997
BTEC Foundation studies in Art and Design, Yeovil College, Somerset

Forthcoming / Current Exhibitions

2006
Tate Gallery, St.Ives, Cornwall (October) (solo)

2007
Mary Mary Gallery, Glasgow (February) (solo)

Selected Exhibitions

2005

Some Newer Formalisms,
Sorcha Dallas, Glasgow (solo)
Liberation de L'aesthethique, The Old Jail,
Tobago Street, Glasgow
Tobias Buche – Nick Evans,
Mary Mary, Glasgow

2004

Red Bus Go, 273 High Street, Glasgow
PILOT 1 International Art Forum,
Limehouse Town Hall, London
From Here to Eternity and Back Again,
Generator Projects, Dundee
Britannia Works, Xippas Gallery and
Ileana Tounta Gallery, Athens

2002

Remember Old Pineapple Face,
Glasgow Project Room (solo)
Lumumba is Dead, Transmission Gallery,
Glasgow (solo)

2001

No Place Uncharted,
The Town Mill Gallery, Lyme Regis, Dorset
October, Public Art Project,
St. Vincent Street, Glasgow
East of Eden, Spacex, Exeter
Return of the Rural, 291 Gallery, London
Under Construction, G39, Mill Lane, Cardiff

2000

Amateur View, Market, Glasgow
The International Festival of the Owl,
Chapter Arts Centre, Cardiff
Art at the Macbeth,
The Hoxton Distillery, London

List of Works

All works courtesy the Artist
and Mary Mary, Glasgow

Black Creature Forms
2006
Spray paint on aluminium
180 x 40 x 50 cm

Black Face
2006
Oil, charcoal, gloss and
emulsion paint on cardboard
40 x 30 cm

Figure X
2006
Coloured polyester resin and
fibreglass on metal stand
220 x 200 x 150 cm

Figure Y
2006
Coloured polyester resin and
fibreglass on metal stand
250 x 220 x 150 cm

Head
2006
Oil, charcoal, gloss and
emulsion paint on cardboard
60 x 40 cm

Models B-J
2006
Glazed, painted terracotta
Dimensions variable

Memorials to the Closed System Schematic
2006
Steel, plaster, fibreglass, coloured resin
on painted plywood and metal base
1. 110 x 110 x 220 cm
2. 120 x 120 x 220 cm
3. 255 x 110 x 220 cm

White Creature Forms
2006
Spray paint on aluminium
85 x 50 x 50 cm

Acknowledgments

This catalogue has been published to accompany the exhibition
Nick Evans Abstract Machines
7 October 2006 – 21 January 2007

Texts by Clarrie Wallis, Gregor Wright and Sara Hughes

ISBN-10: 1 85437 710 8
ISBN-13: 978 185437 7104
A catalogue record for this publication is available from the British Library

Edited by Susan Daniel, Sara Hughes, Arwen Fitch and Kerry Rice
Design by Andrew Smith
Repro and Print by Eden, Cornwall

Tate St Ives, Porthmeor Beach, St Ives, Cornwall TR26 1TG

The Artist Residency Programme and exhibition has been supported by Arts Council England, South West; the Scottish Arts Council; Hope Scott Trust; University College Falmouth; Tate St Ives Members and Tate Members

Cover image
White Creature Forms (detail)
2006
Spray paint on aluminium
85 x 50 x 50 cm
Photo: Dave Clarke and Andrew Dunkley © Tate

Nick Evans at Tate St Ives 2006
Photo: Dave Clarke and Andrew Dunkley © Tate